PEACE DANCER

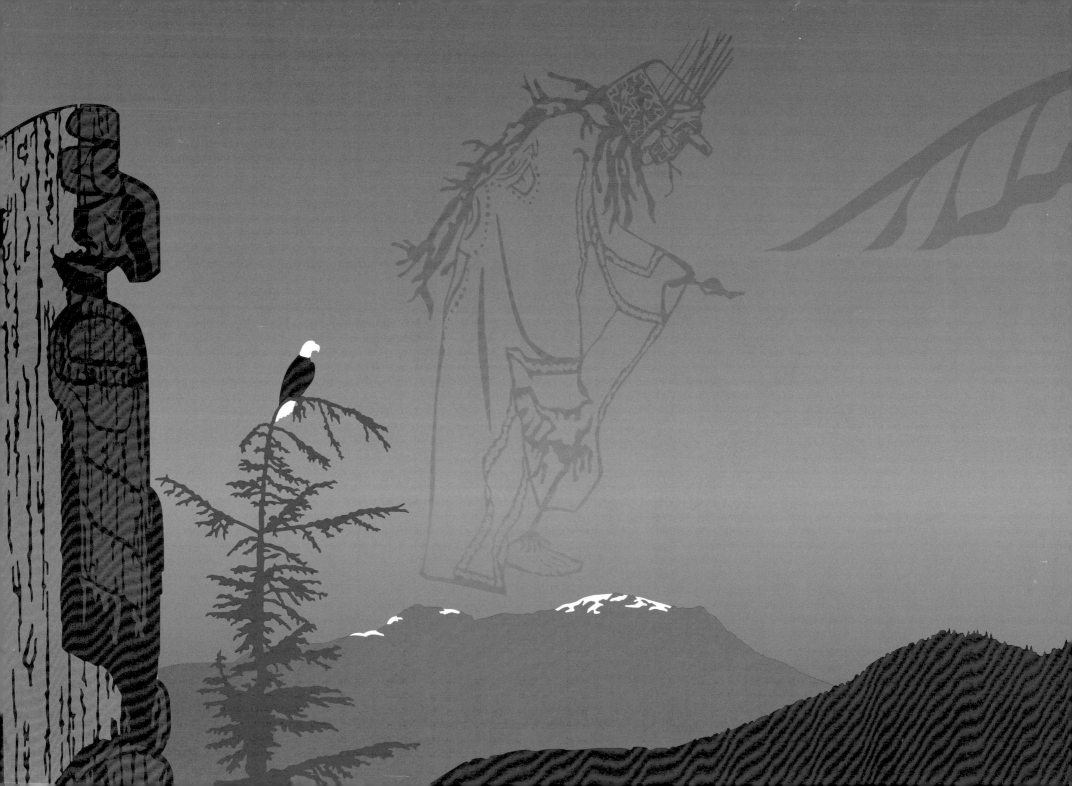

ROY HENRY VICKERS *and* ROBERT BUDD

Illustrated by ROY HENRY VICKERS

PEACE DANCER

HARBOUR
PUBLISHING

Also by Roy Henry Vickers and Robert Budd

Raven Brings the Light
Cloudwalker
Orca Chief

Harbour Publishing Co. Ltd.
P.O. Box 219, Madeira Park, BC, V0N 2H0
www.harbourpublishing.com

Typesetting by Shed Simas
Printed and bound in Canada

Harbour Publishing acknowledges the support of the Canada Council for the Arts, which last year invested $157 million to bring the arts to Canadians throughout the country. We also gratefully acknowledge financial support from the Government of Canada through the Canada Book Fund and from the Province of British Columbia through the BC Arts Council and the Book Publishing Tax Credit.

Cataloguing data available from Library and Archives Canada
978-1-55017-739-8 (cloth)
978-1-55017-740-4 (ebook)

This story comes from my village of Kitkatla on the north coast of British Columbia. All of our knowledge was passed on through stories, songs and dances. This story is as old as the tides that rise and fall on our shores, yet the lessons taught may be more important now than they were thousands of years ago.

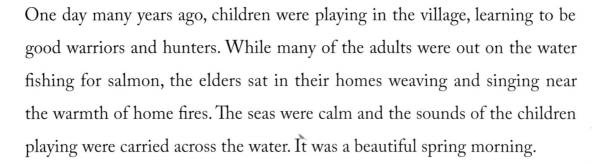

One day many years ago, children were playing in the village, learning to be good warriors and hunters. While many of the adults were out on the water fishing for salmon, the elders sat in their homes weaving and singing near the warmth of home fires. The seas were calm and the sounds of the children playing were carried across the water. It was a beautiful spring morning.

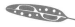

The children decided to make a trap. A boy brought a bentwood cedar storage box that an artist had made. A girl brought a small stick that she found lying amidst the kelp on the beach. The children worked together, tying a cedar bark string to the stick.

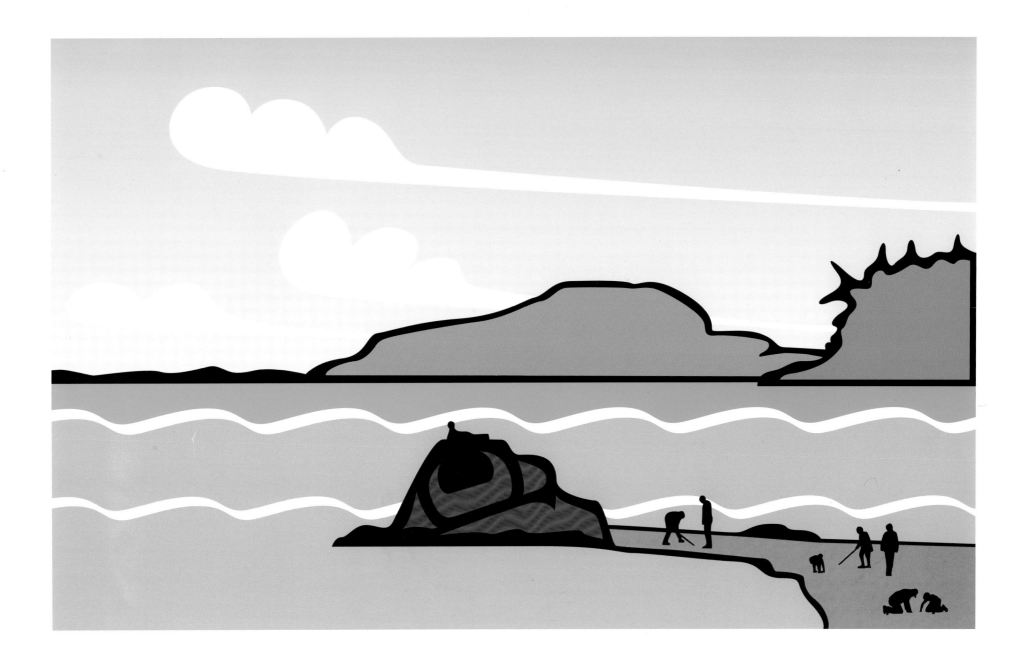

One of the boys ran home and grabbed some bread to put on the ground close to some bushes. The cedar box was placed carefully over the bread. The stick with the string held up the box so that a quick tug on the string would cause the box to fall and trap whatever came along to eat. The children hid behind the bushes, holding the string in silence.

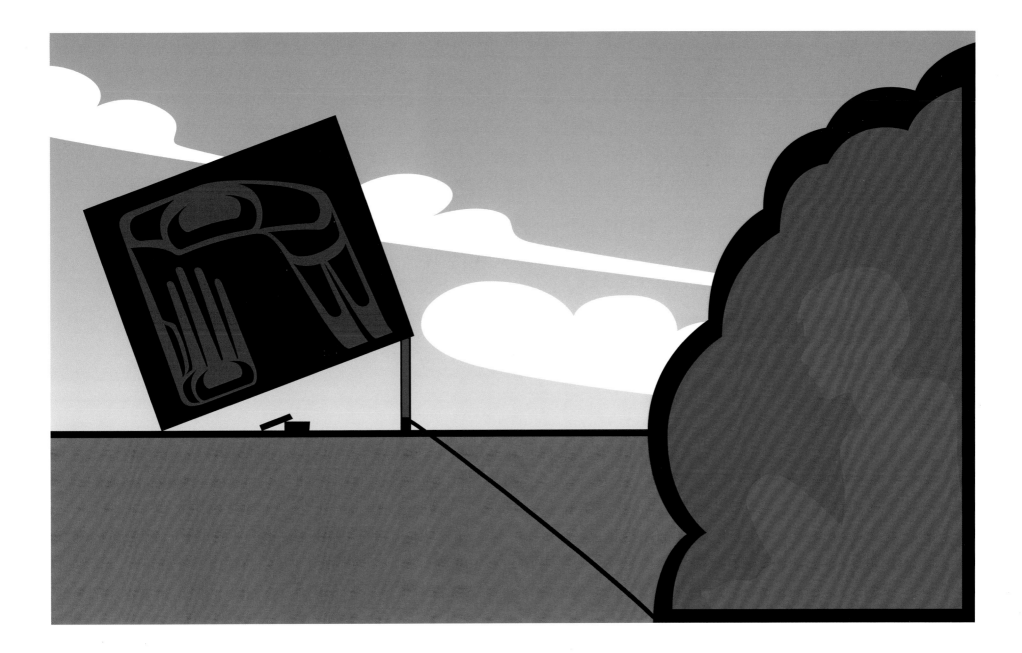

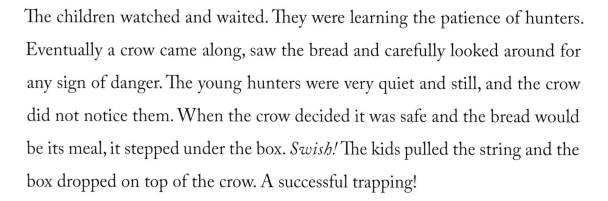

The children watched and waited. They were learning the patience of hunters. Eventually a crow came along, saw the bread and carefully looked around for any sign of danger. The young hunters were very quiet and still, and the crow did not notice them. When the crow decided it was safe and the bread would be its meal, it stepped under the box. *Swish!* The kids pulled the string and the box dropped on top of the crow. A successful trapping!

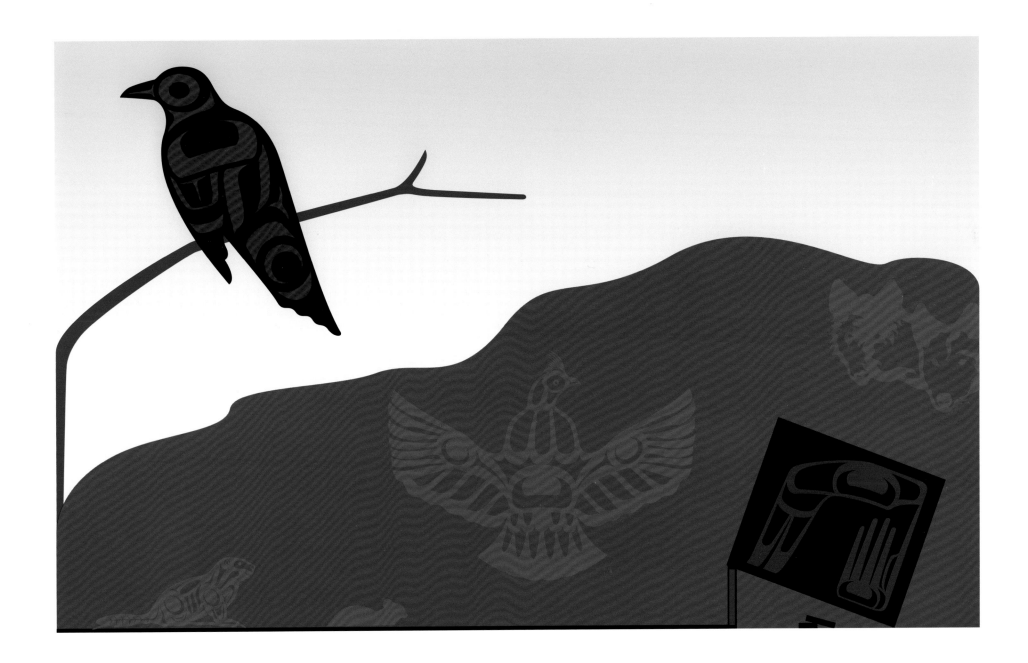

The children should have set the crow free. Instead they tied a string to its foot so it could not get away and pulled feathers from its wings. When they saw that it could still fly, they pulled the crow back and removed more feathers. Before long the ground was covered with feathers, and the crow could no longer fly. These children were not taught that we must respect all life.

The skies darkened as storm clouds suddenly gathered overhead. The spring breeze from the west we call *Goolka* changed to *Hiwaas*, which means southeast winds. Southeast winds always bring a storm and rain. The calm seas turned choppy. The fishermen quickly pulled in their nets before the waves got too big for their small fishing canoes. The rains came.

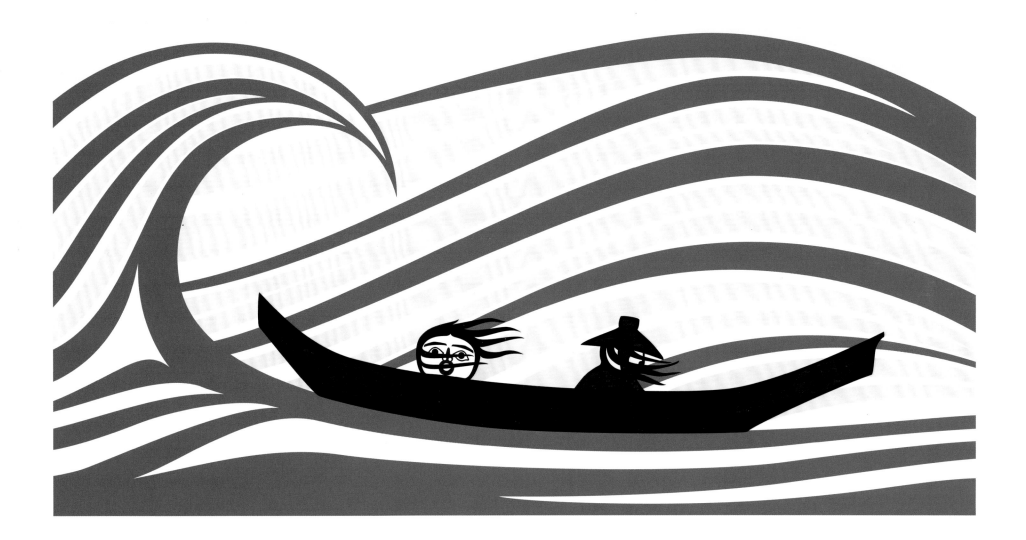

The Tsimshian people of Kitkatla are used to the rain. The name *Tsimshian* actually means "in the rain." Many days of wet weather are normal for those born in the rain, but this storm did not stop. Day after day, week after week, the storm continued. Waves crashed on the shore and pounded the village.

Then came the flood waters.

The water kept coming up and up, covering the beaches. Soon it would seep into the houses. The people realized this storm was not going to stop. Water kept rising and the people of the village were afraid.

The people realized that they could not stay in their homes. Everyone in the village got into their biggest canoes. They had to paddle to higher ground.

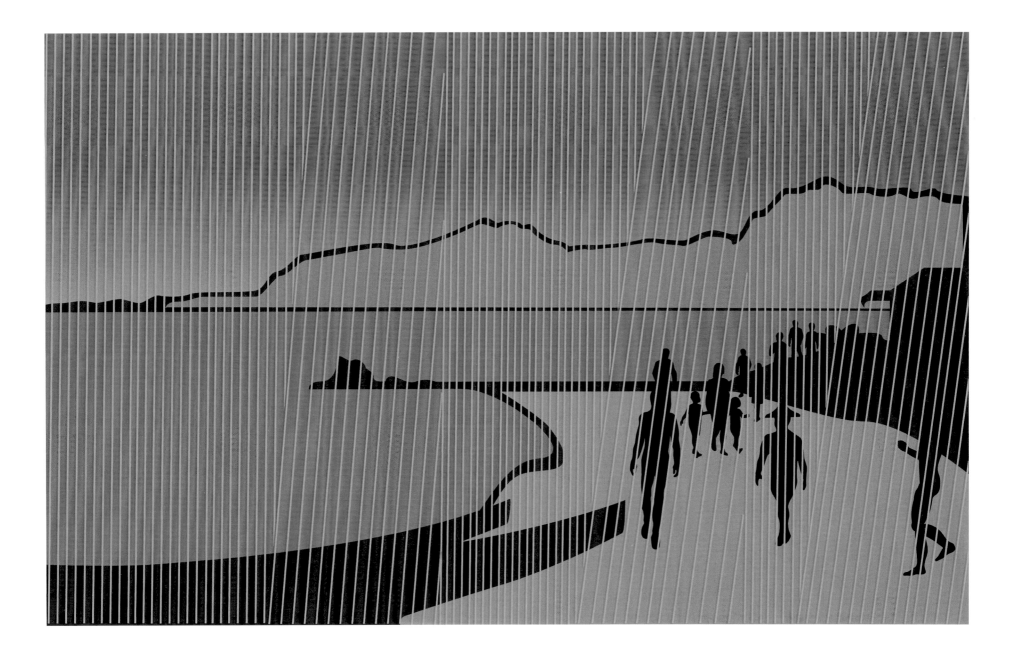

The canoes were thrown this way and that in the stormy seas. The waters were rising swiftly, but the canoes made it to the tall mountain not far from Kitkatla.

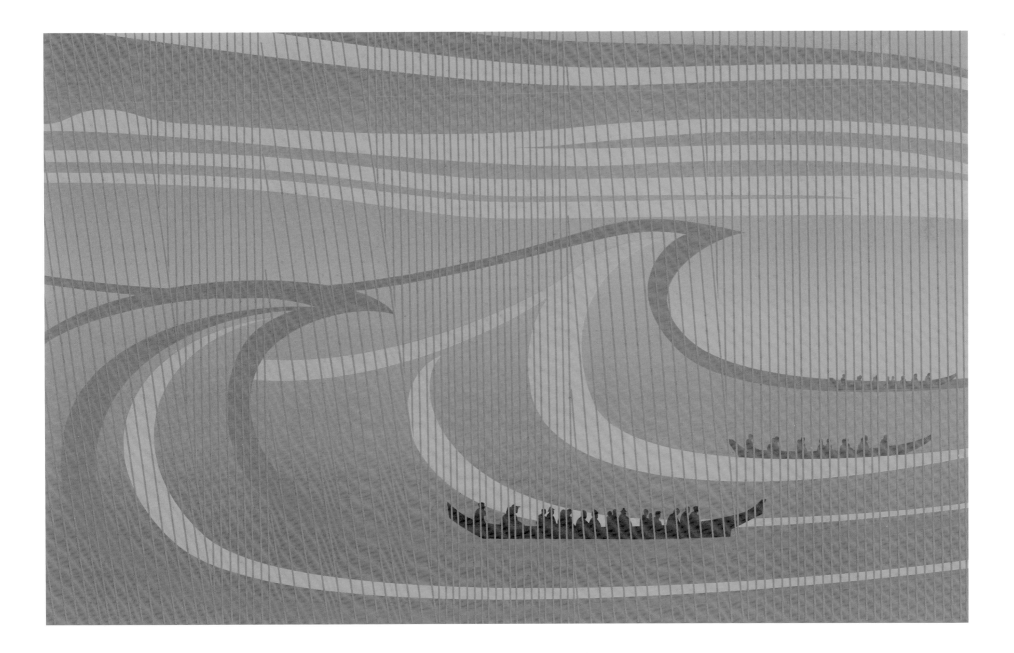

The people carefully dropped their big anchor down to the mountaintop that was now under water. They passed ropes from canoe to canoe, holding them all together.

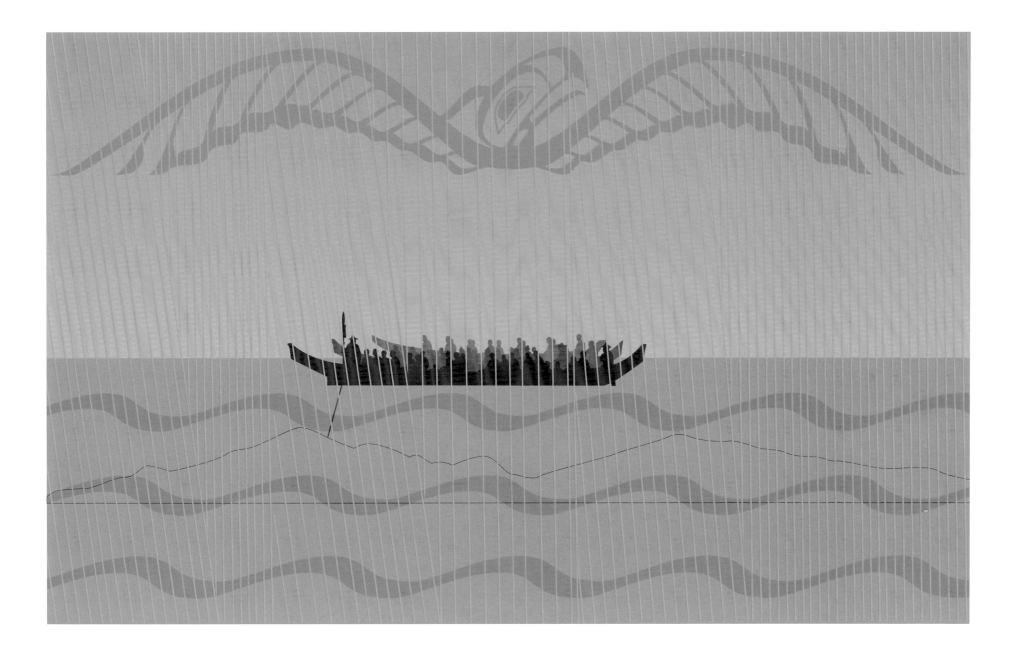

The strong people bailed the water out of the canoes as the rain kept falling. The old people were crying and praying to the Chief of the Heavens. They said, "Please have mercy on us! Bring peace back to the world. Please make the storm stop!"

But the storm did not stop.

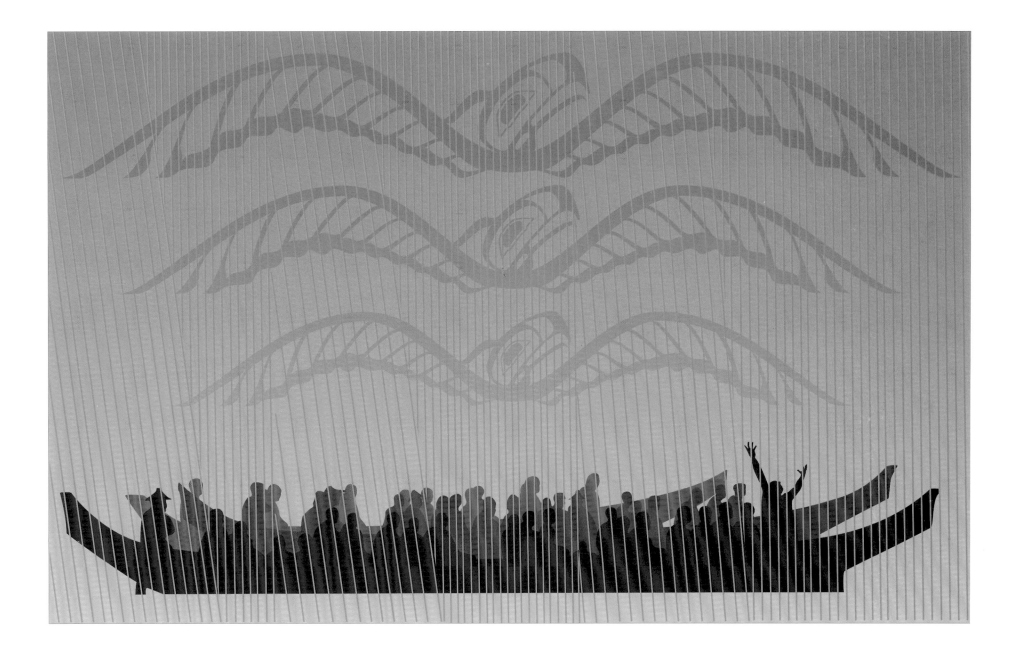

Finally one of the elders fell asleep. When she woke up she declared to the others, "I had a vision! I see our return home! We have really lost our way. We have not taught our children love and respect. The Creator is angry with our behaviour." Then the people prayed and promised the Chief of the Heavens they would return to the laws of the ancestors, the laws of love and respect.

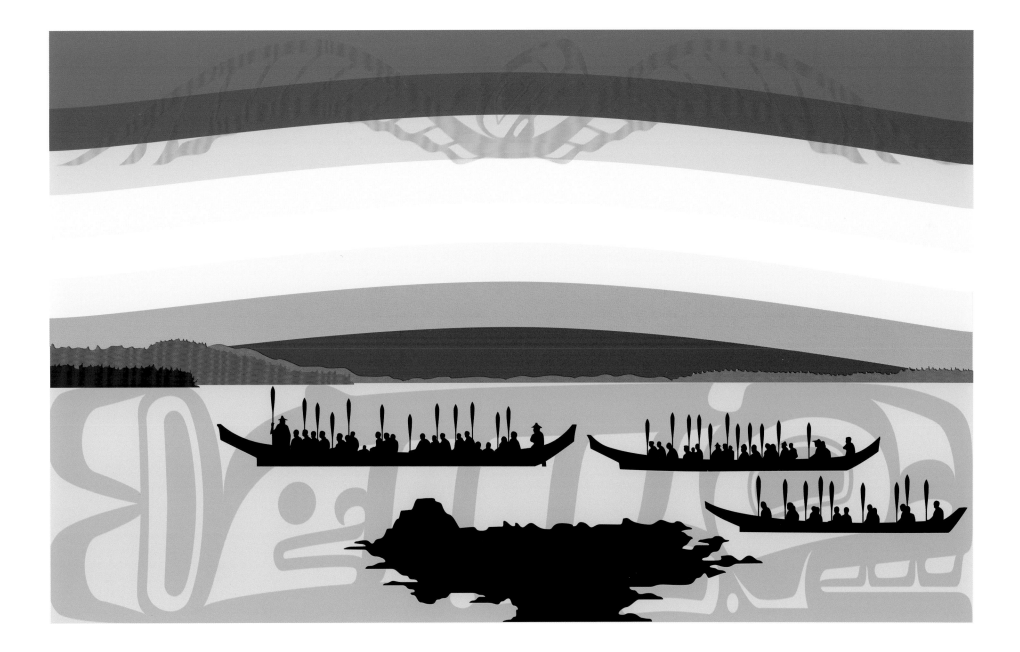

As the rains continued to pour, the Chief of the Heavens looked down at all the birds and saw that they couldn't land anywhere. Eagles, crows, loons, geese, herons, hawks, woodpeckers, grouse and many other birds were flying around and bumping into each other. Their feathers were falling into the ocean.

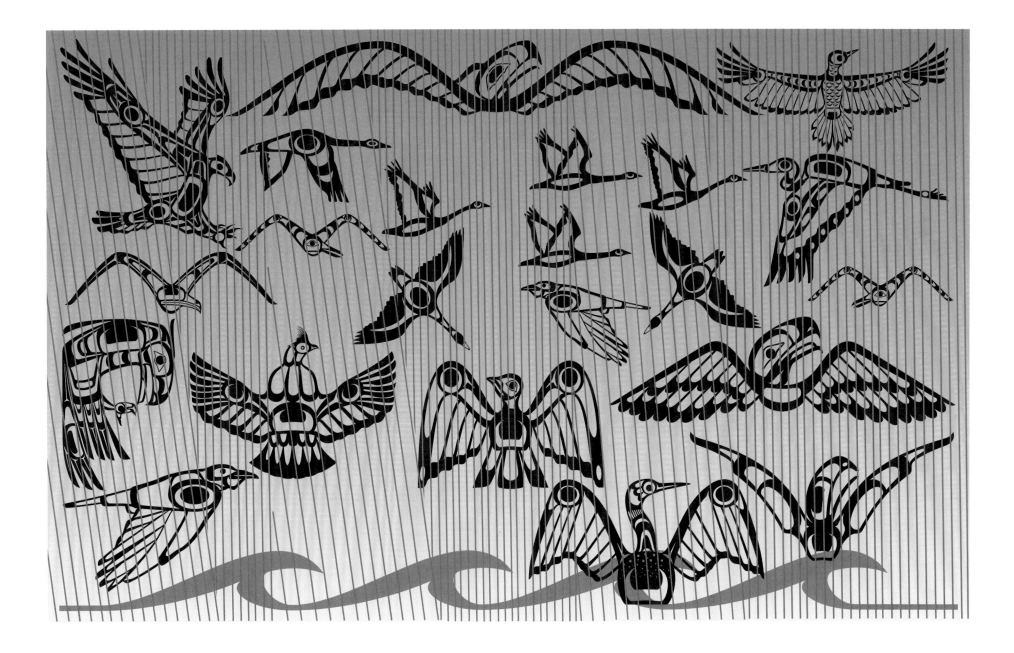

The Chief of the Heavens said, "There is no reason for the animals to suffer because the people have lost their way. I have heard the people's prayers and promises that they will change, so I will bring peace back to the world."

The Chief of the Heavens felt love and compassion, and the storm ended and the winds stopped. As the sun broke through the clouds, the flood waters went down, and fresh grasses, flowers and berries began to grow. The birds and animals made new homes. All the Earth was happy.

The people were humbled and thankful for the lesson they had learned. After months of hard work, they rebuilt their village. They returned to the laws of their ancestors and to this day, the mountain where they anchored their canoes is still called Anchor Mountain.

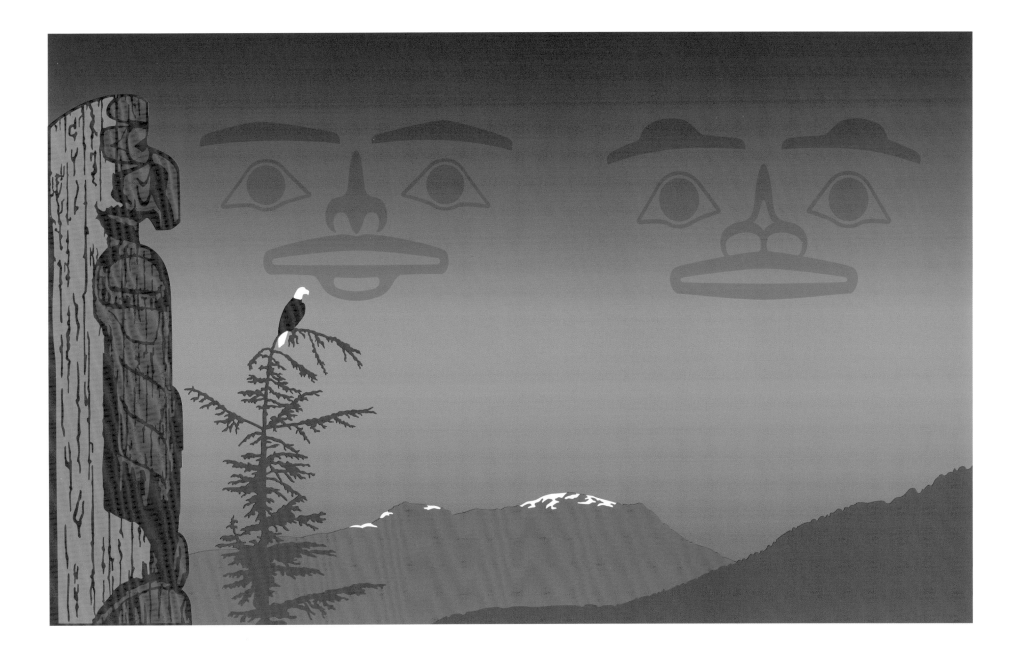

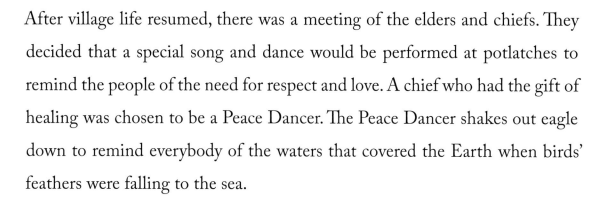

After village life resumed, there was a meeting of the elders and chiefs. They decided that a special song and dance would be performed at potlatches to remind the people of the need for respect and love. A chief who had the gift of healing was chosen to be a Peace Dancer. The Peace Dancer shakes out eagle down to remind everybody of the waters that covered the Earth when birds' feathers were falling to the sea.

Author's Note

The first time I saw the Peace Dance, I was a young man attending my first potlatch. I asked one of the elders who was sitting with me at the feast why the dancer was shaking out eagle down. The answer was: "He is blessing the people." I wondered for many years what "blessing the people" meant. I could feel the importance of this dance.

Many years later as a young artist, I went to visit my friend, Chester Bolton, the man who told me the story *Raven Brings the Light*. On this occasion, Chester said to me, "I want to tell you a story today, Roy. This story comes from Kitkatla. When I'm telling this story, you will know some things because the story will be familiar to you. I want you to remember this story, Roy." So it was that I first heard the story of The Flood as my people have always known it.

Today I am Chief Tlakwagila from the House of Walkus in Owikeeno. I am also the Peace Dancer for my head chief, Hosumdas, of the House of Walkus. I was taught the Peace Dance by another chief who has passed on. When I was initiated as a Peace Dancer, my first dance was at a feast in Waglisla, or Bella Bella. So it is that I have come to know this dance that originated after the time of the great flood. Our stories are important. They hold lessons for all who are willing to learn. The Peace Dance is a very important part of every potlatch to this day.

Roy Henry Vickers — Hemas Tlakwagila
House of Walkus in Owikeeno, BC

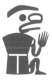

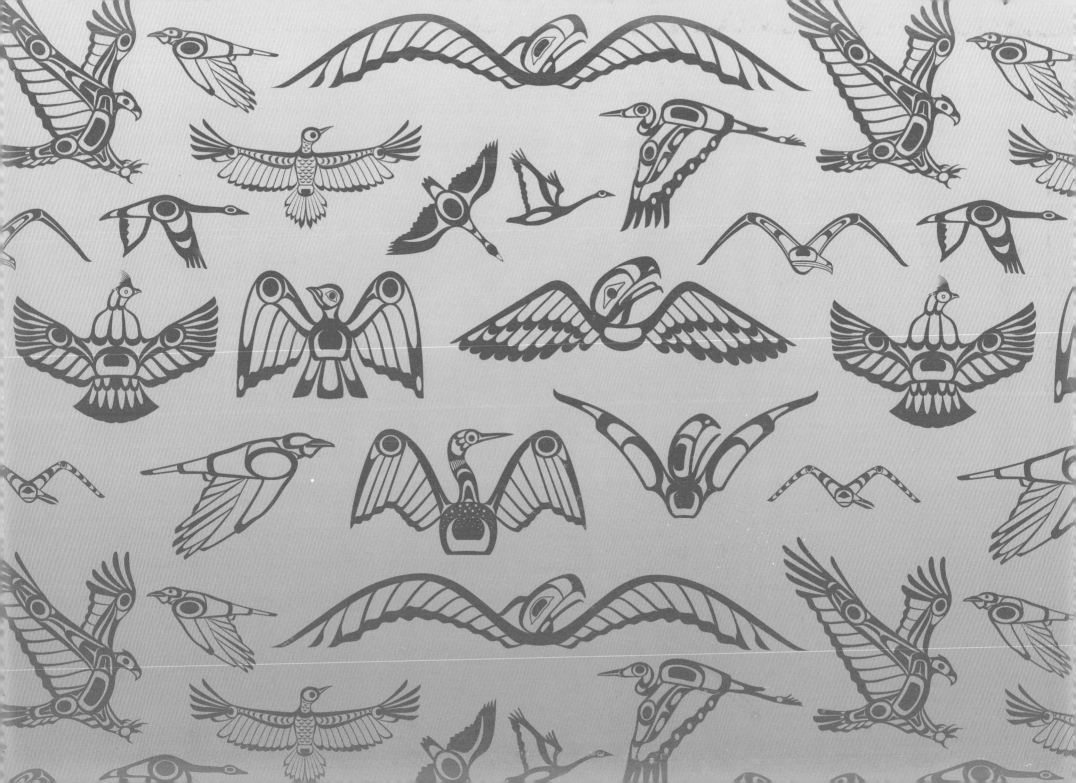